HENNA, PLEASE!

BODY ART AROUND THE WORLD

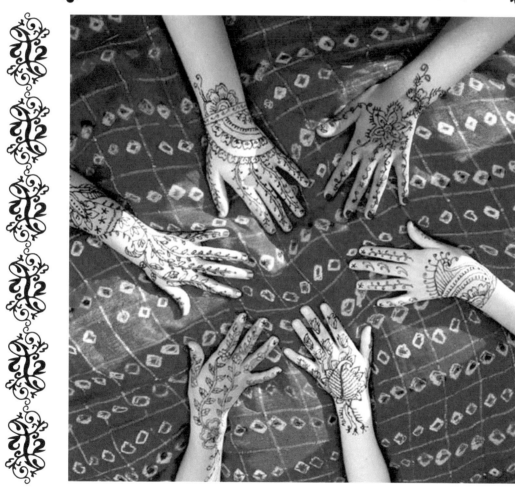

SOHNIE LUCKHARDT ~ MINA KUMAR

AuthorHouse™
1663 Liberty Drive
Bloomington, IN 47403
www.authorhouse.com
Phone: 1 (833) 262-8899

Because of the dynamic nature of the Internet, any web addresses or links contained in this book may have changed
since publication and may no longer be valid. The views expressed in this work are solely those of the author and do not
necessarily reflect the views of the publisher, and the publisher hereby disclaims any responsibility for them.

Any people depicted in stock imagery provided by Getty Images are models,
and such images are being used for illustrative purposes only.
Certain stock imagery © Getty Images.

This book is printed on acid-free paper.

ISBN: 978-1-7283-6897-9 (sc)
ISBN: 978-1-7283-6896-2 (e)

Library of Congress Control Number: 2020914203

Print information available on the last page.

Published by AuthorHouse 10/07/2020

authorHOUSE®

TO UPLIFT THE SPIRITS OF CHILDREN EVERYWHERE

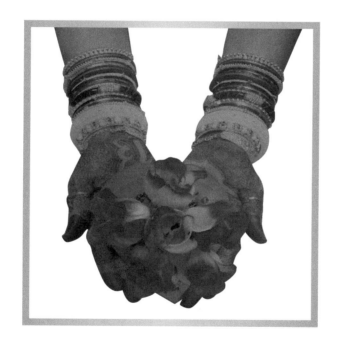

To the Leodora-Romero Family

On February 18, 2009, eleven-year-old Luis and four-year-old Jorge Romero lost their mother, Antonia Leodora, and little brother, Ricardo, in an apartment fire. Although the community rallied in support with generous offerings of food, clothing, and money, we may never know the sense of loss and depth of sorrow this family has endured. We offer this book in hopes that these beautiful, delicate, and intricately drawn designs on the hands and feet of children will uplift their spirits and bring hope for a brighter future.

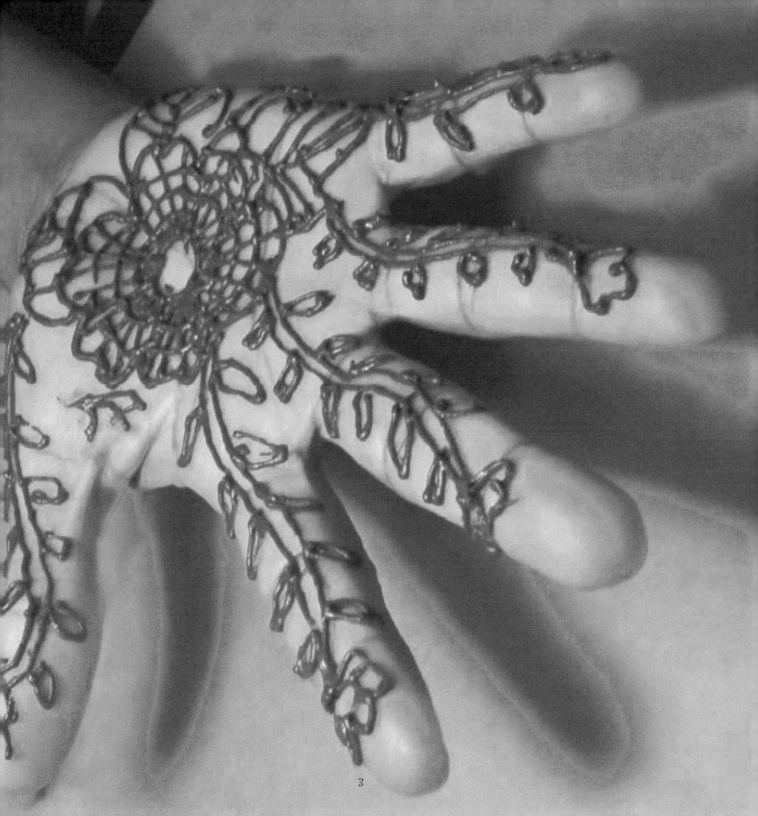

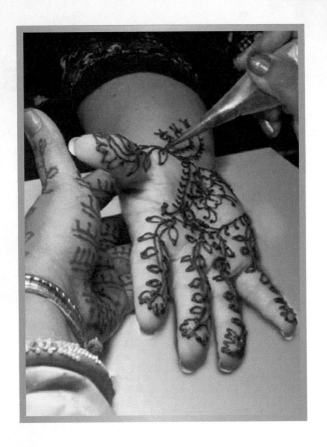

Have you ever heard the word *henna*? How about the word *mehndi*? Have you ever wondered how some people get beautiful designs drawn on their bodies? Imagine how it would look and feel to have a henna design drawn on your body.

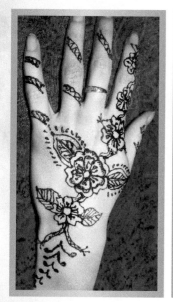
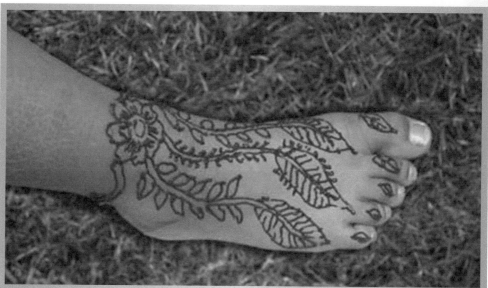

The art of applying henna to the body has been practiced for more than five thousand years and has a history in many countries around the world. In India, the art of applying henna to the body is a Hindi word, *mehndi*. Like a tattoo, mehndi decorates the body with beautiful designs.

The Latin name for the henna bush is *Lawsonia inermis*. It grows in the Middle East and other areas where the climate is hot and dry. The bush has small, four-petaled flowers that range in color from yellow to pink. Its leaves contain hennotannic acid that produce a red dye. Top leaves of the plant are best for mehndi, while the bottom part is used for other purposes.

Most people know henna as either a hair treatment or temporary tattoo. Very few know that henna is also a great medicinal plant and is used in Ayurvedic and Unani medicine. Henna is known for its cooling properties. For this reason, it can be used as an herbal remedy for burns, scrapes, and headaches. It can also treat a variety of rashes, including ringworm and athlete's foot.

The henna bush is harvested twice a year, dried and then crushed to make henna powder. Henna powder is green in color, but the stain it leaves is usually orange-red.

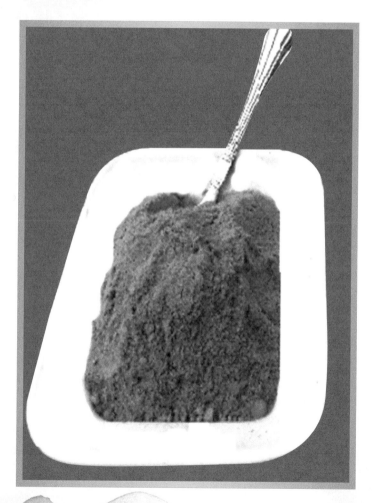

The powder can be mixed with a variety of ingredients, such as lemon juice, black tea, or lime juice. After the paste is mixed, it is put into cones. Pure henna paste is very safe and has a pleasant smell when mixed with scented oils.

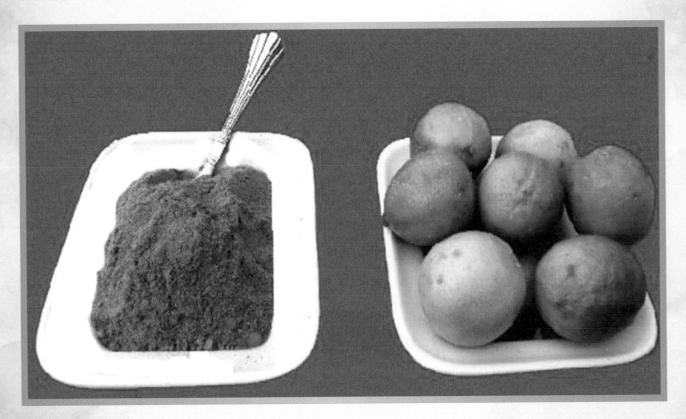

Henna paste can be drawn on your skin in several different ways. Usually plastic cones are filled and used for drawing the designs. These cones can be purchased from specialty shops, or you can make your own. Other methods for applying henna paste include using squeeze bottles, twigs, or even pieces of silver wire.

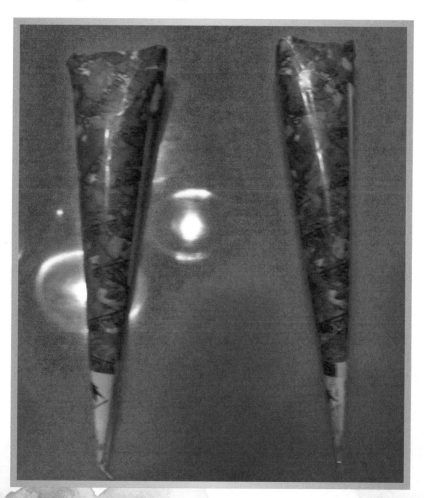

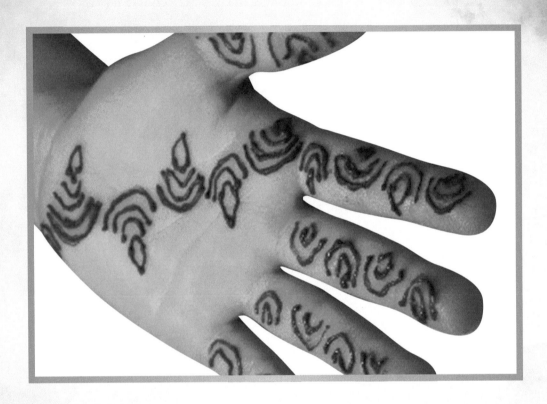

Applying henna to your body does not hurt. In fact, some children say it feels cooling and tickles. Others say it makes them feel happy and brave. Many people believe henna brings good luck and good fortune to those who wear it.

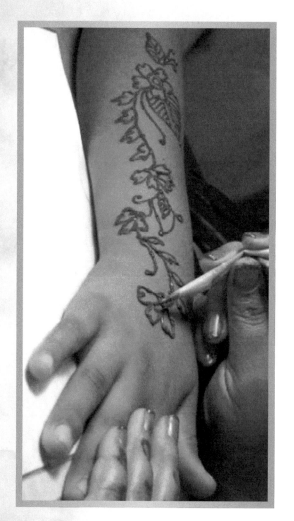

Getting a henna tattoo requires you to sit still while the paste is being applied. As the paste dries, the skin absorbs the color of henna. Whether your design is light or dark depends on how long the paste is left on and the properties of your skin.

A henna tattoo does not wash off with soap and water. Instead it wears off gradually within a week to ten days. It is very calming and relaxing to have henna designs drawn on your body.

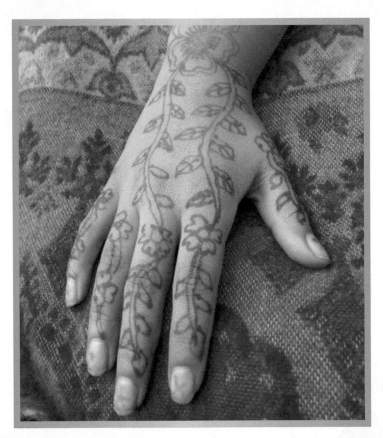

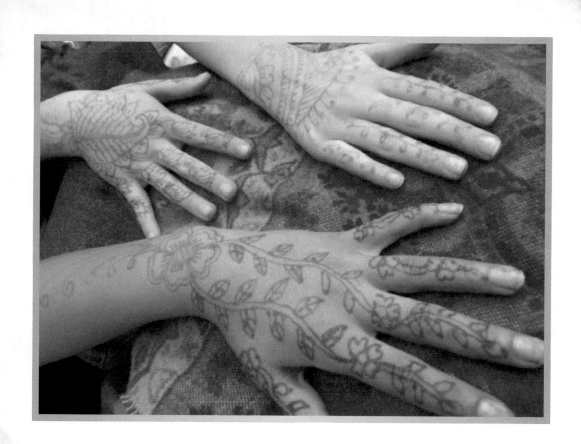

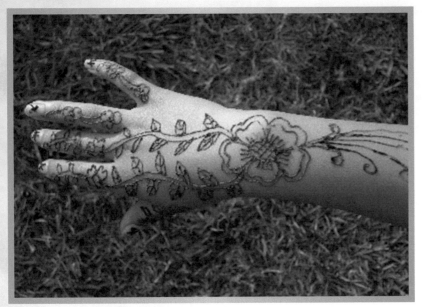

There are several different styles of beautiful henna patterns. The Middle Eastern style is similar to Arabic paintings and is patterned after flowers.

North African designs tend to be larger geometric shapes.

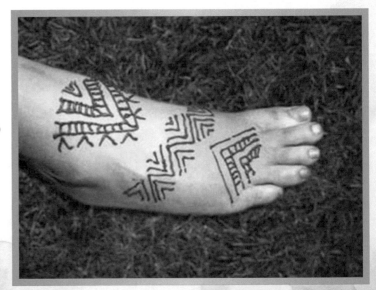

The Indian and Pakistani designs are made of fine lines of patterns and teardrops that cover the entire hand and foot.

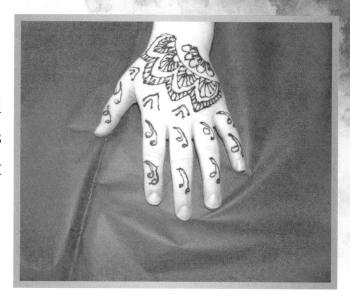

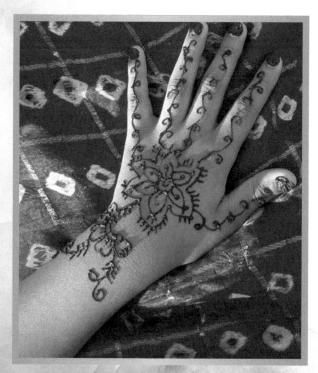

Indonesian and South Asian styles mix the Middle Eastern and Indian designs using blocks of color on fingertips and toes.

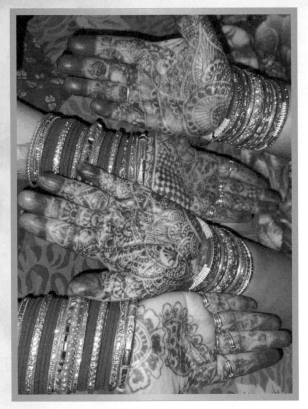

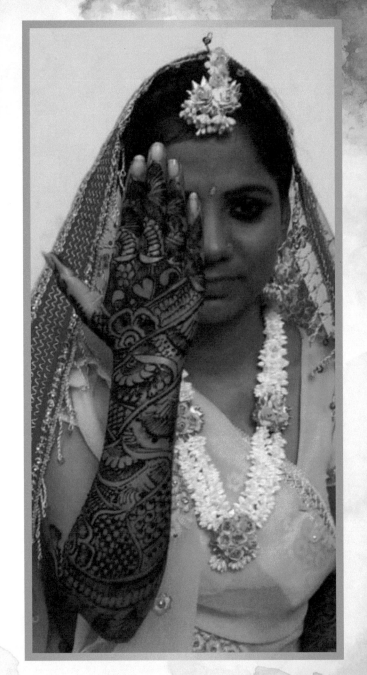

Often henna is used in Indian culture as a ceremonial art form for weddings. Many people in India say that the love of the groom can be measured by the intensity of the color remaining on the hands of the bride—the darker it is, the stronger their bond.

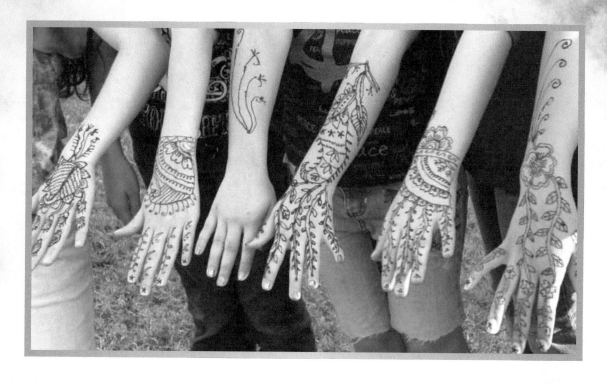

Although henna is used in religious and ritualistic ceremonies, it can be appreciated and enjoyed at any time. Henna parties are often given to celebrate special occasions. Today people often have henna applied for birthdays, graduations, and just for fun. Henna designs bring great happiness into our lives.

Traditionally only girls received henna, but today in America boys enjoy it too.

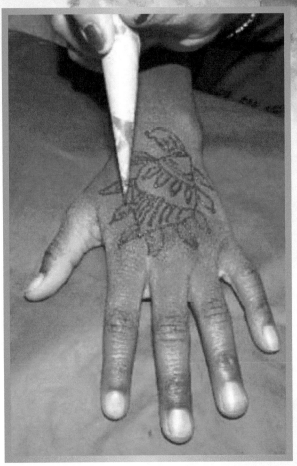

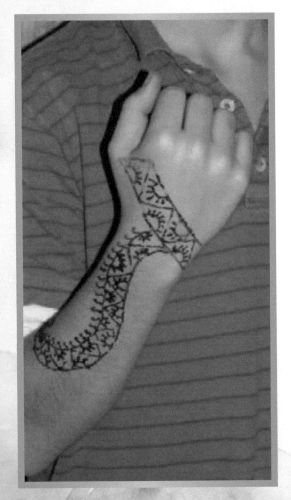

Modern henna tattooing has become part of many cultures around the world.

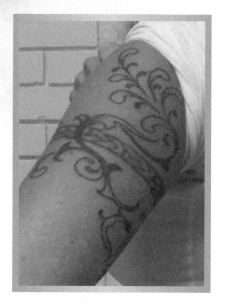

Some people choose to wear a traditional Indian design, while others use henna tattooing as a replacement for a modern-day tattoo. It's a great way to express your individuality, and it's not permanent.

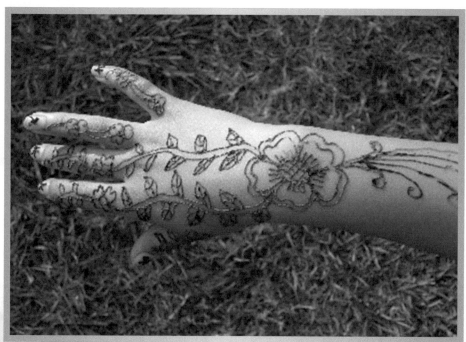

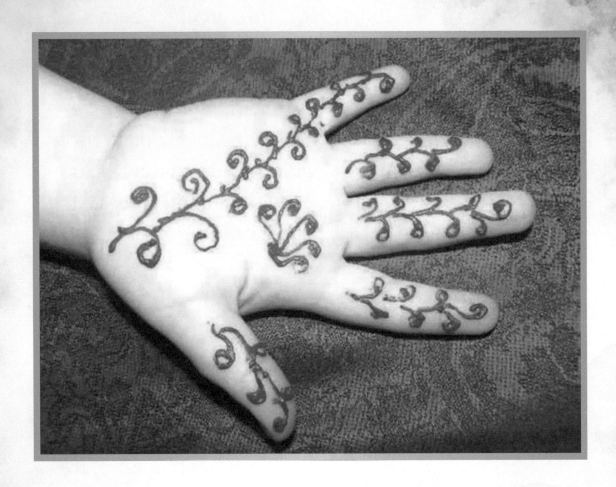

Whatever your level of interest in henna, you are entering into a beautiful art form rich in history and culture. Take time to enjoy feeling special by having your body adorned with these gorgeous designs.

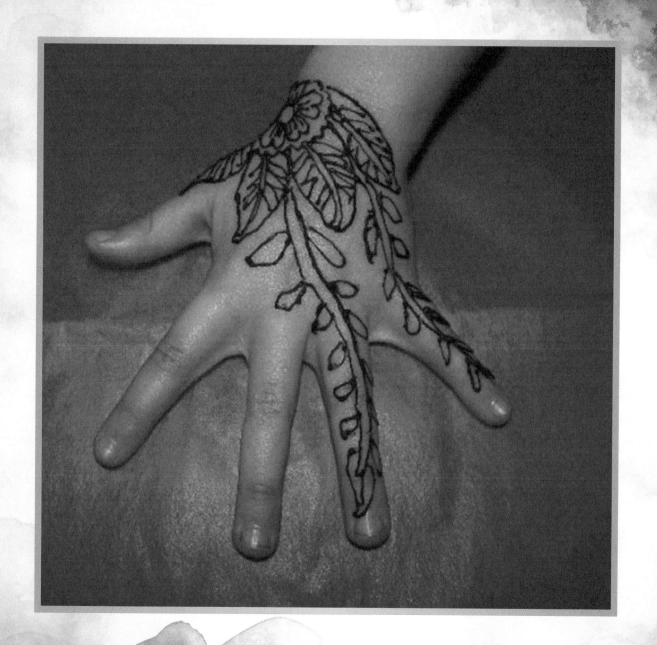

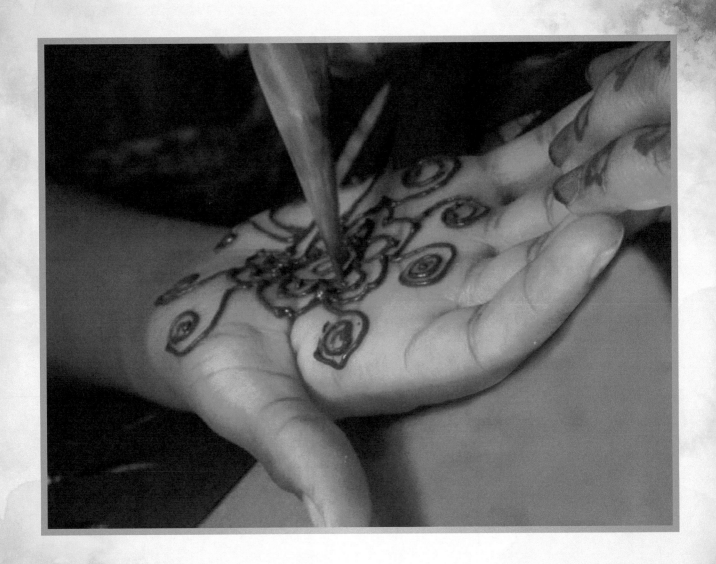

Each time you sit quietly to have a henna design drawn on your body, relax, take a deep breath, and gently close your eyes. Feel the cool and tingling sensation as the henna paste slowly touches your skin. In that calm and relaxing moment, we wish you happiness and the understanding that each day is a precious gift and reason for celebration.

26

Gallery

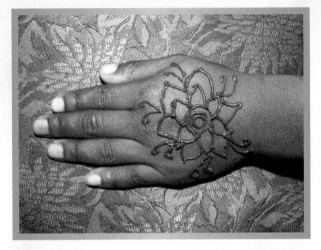

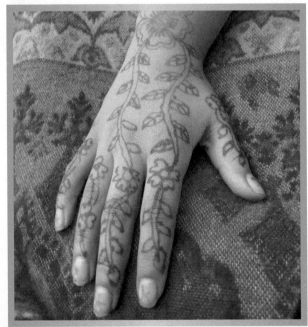

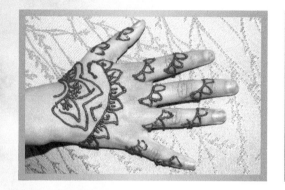

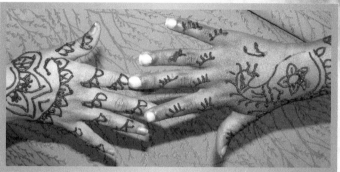

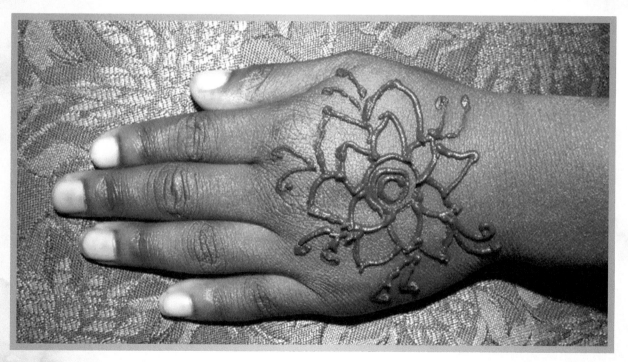

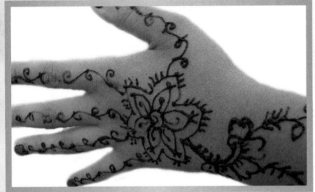

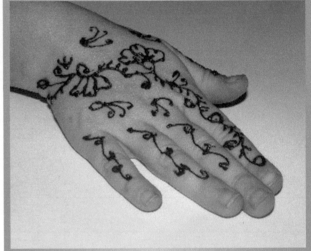

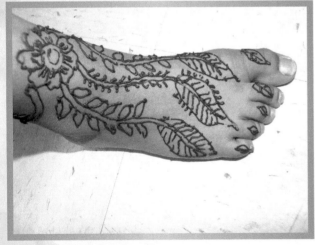

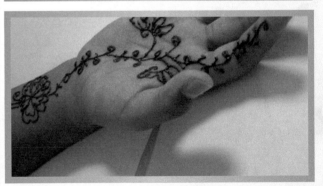

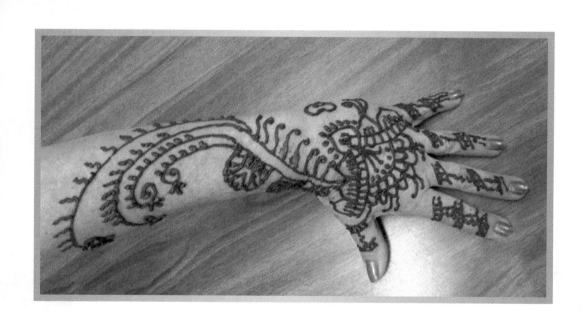

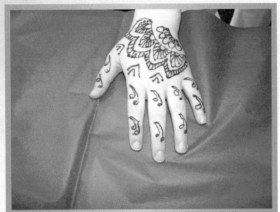

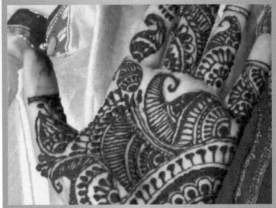

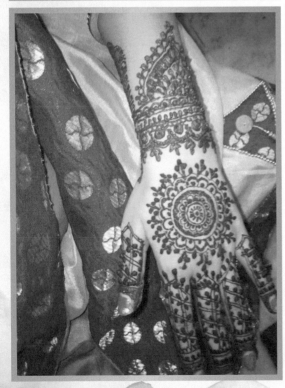

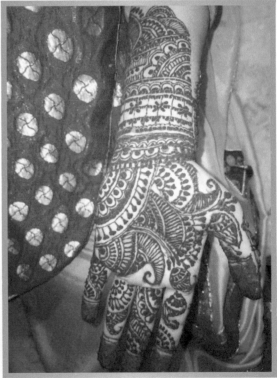

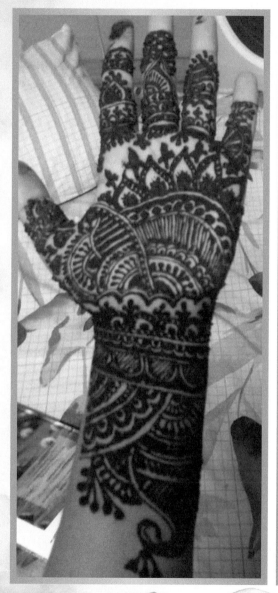

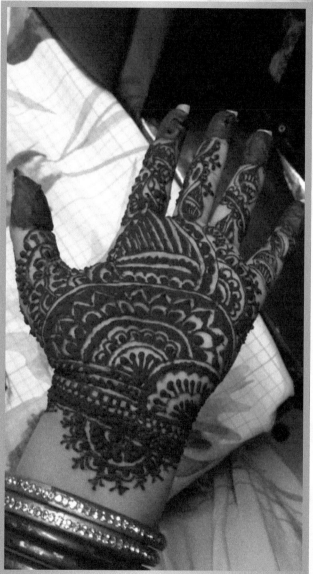

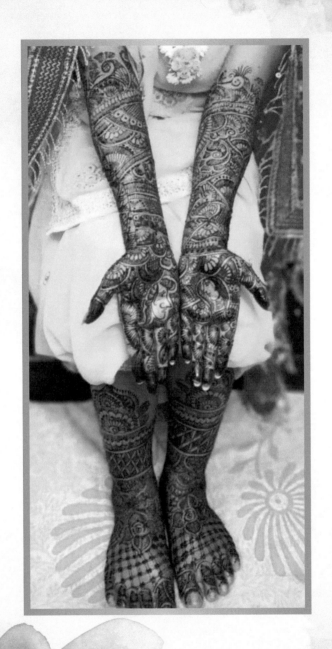

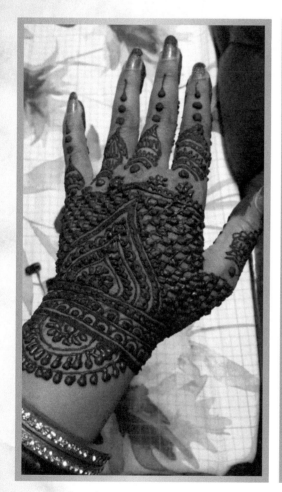

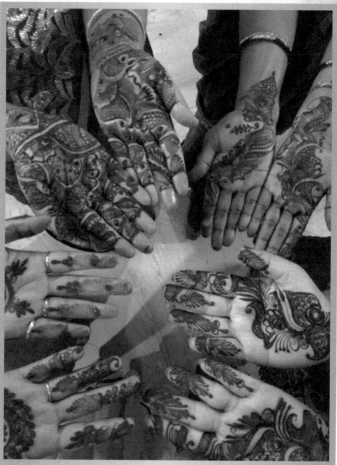

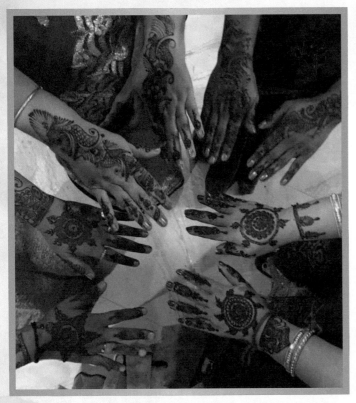 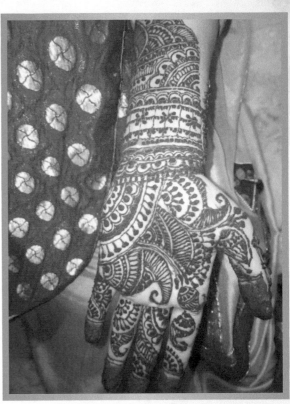

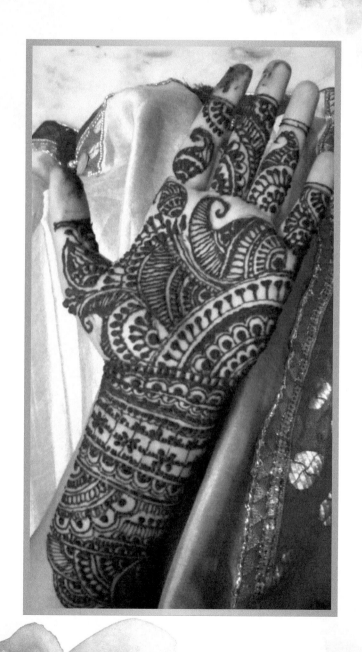

About the Author

Sohnie Luckhardt has been in the field of education for 41 years and has devoted much of her career to educating young children. She completed her Bachelor of Arts degree in psychology and sociology at Hope College in Holland, Michigan in 1973. She earned a professional diploma in early childhood education from the University of Hawaii at Manoa in 1978. In addition, she has traveled extensively, teaching English as a Second Language in Japan and Singapore, and working with under-privileged children in India. She has worked in a variety of early childhood settings including Montessori and Waldorf schools, a Hebrew Day school, and the Child Development Center at the University of Michigan.

Luckhardt moved to Atlanta in 1995 to attend Life Chiropractic University. Her interest was in pediatric chiropractic studies and how chiropractic intervention could help children with learning disabilities and ADHD. During this time, she worked in the after-school care program at Covered Bridge Montessori School.

With the prospect of a primary teaching position and Montessori training, she was inspired to rethink her career direction. She made the decision to return to education full-time and pursue Montessori certification. Her happiness with this decision underscores the fundamental nature of her life's work—helping others learn and grow. She believes that Montessori philosophy is most conducive to creating supportive, healing, and peaceful learning environments.

About the Henna Artist

Mina Kumar was born in India in the state of Bihar. Her middle-class family included her parents and three older brothers. Her father worked for the government, which required moving to a different city every three years. Kumar transferred to different schools often and came into contact with many of the diverse communities in India. Eventually she graduated with her Bachelor of Arts and completed her Master's in Indian classical music.

A few years later, Kumar married and moved to the United States, settling in North Carolina, where her first son was born. A year later, the family moved to Wisconsin, where her second son was born. They eventually relocated to Georgia, settling in the suburbs of Atlanta.

Kumar started volunteering in the library at her children's elementary school, eventually becoming a Montessori paraprofessional. She was later employed as an after-school care program instructor, where she engaged students in arts and crafts, which she finds to be a very pleasurable hobby. One component is henna, which is a significant part of her Indian culture, particularly its ceremonies. It ties together her roots with her passion for art. She has embraced the opportunity to share this part of herself with others by applying henna and teaching about the beautiful and rich traditions that make henna more than just a dye.

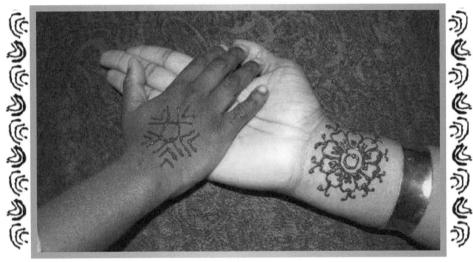

"There are so many reasons to be happy and one of them is henna leaving a beautiful dark stain!"

www.BlingSparkle.com

41

Printed in the United States
By Bookmasters